Calligraphy

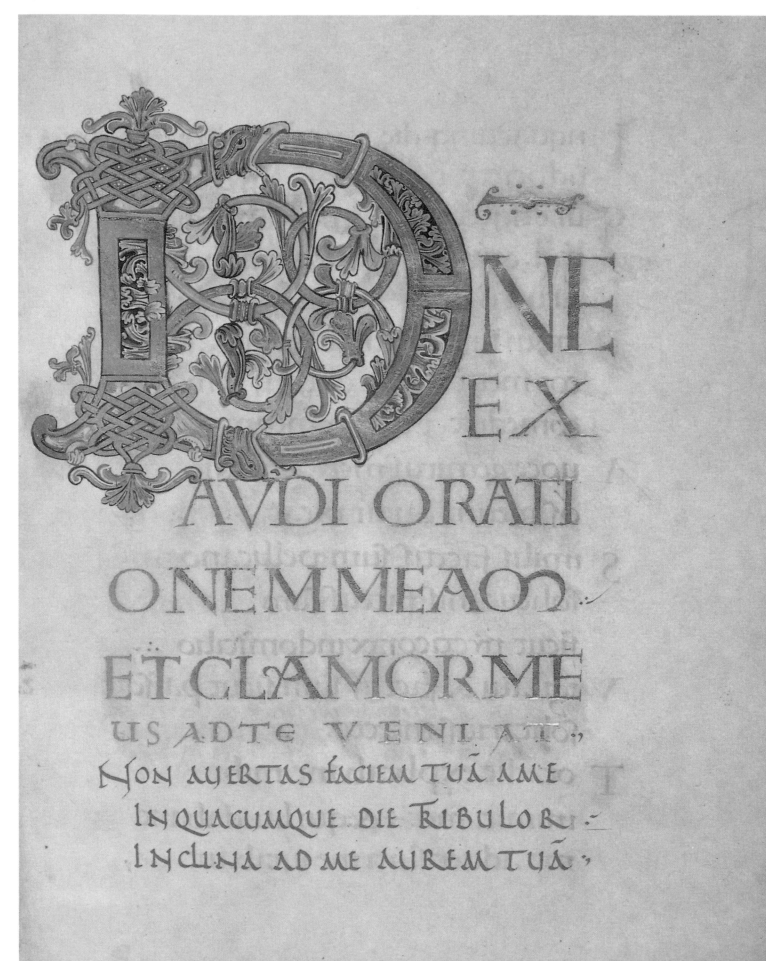

DNE EX
AVDI ORATI
ONEMMEAM
ET CLAMORME
US AD te VENIAT
NON AVERTAS faciem tuā AME
IN QUACUMQUE DIE tribulor
INCLINA AD ME AVREM TVA

· THE TREASURY OF DECORATIVE ART ·

Calligraphy

MICHAEL GULLICK

MOYER BELL

Wakefield, Rhode Island & London

Frontispiece:

AN ANGLO-SAXON PSALTER

Late tenth century, England

Courtesy of the British Library , London (Harley 2904).

Page 6:

**A DECORATIVE MANUSCRIPT BY
JOHANN HOLTMAN**

c. 1529, Germany.

Courtesy of the British Library, London (Add 31845).

Published by Moyer Bell
This Edition 1996

Copyright © Studio Editions Ltd, 1996

LIBRARY OF CONGRESS
CATALOGING IN PUBLICATION DATA

Gullick. Michael. Calligraphy: the treasury of decorative art / Michael Gullick. 1st ed.

NK 3600.G94 1995 95-22148
745.6 197-dc20 CIP

1. Calligraphy. I. Title

ISBN 1-55921-152-0

Printed & bound by ORIENTAL PRESS, (DUBAI).

Distributed in North America by Publishers Group West, P.O. Box 8843, Emeryville
CA 94662, 800-788-3123 (in California 510-658-3453) and in Europe by
Gazelle Book Services Ltd., Falcon House, Queen Square, Lancaster LA1 1RN England.

CONTENTS

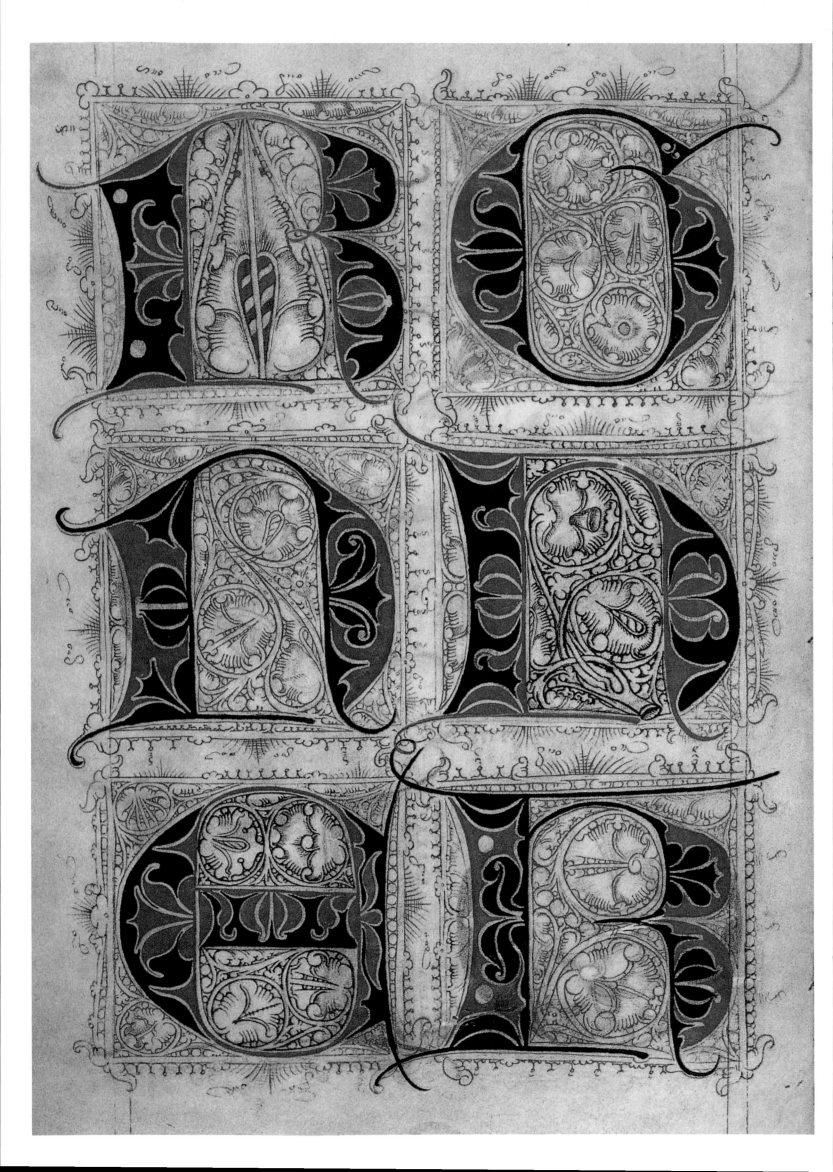

INTRODUCTION

Only a little more than five hundred years ago all books were written by hand. The earliest printed books appeared in the 1450s and it was then possible to produce multiple copies of a text rapidly. Medieval scribes and early printers would be astonished to learn that today there are machines which can not only read but also write. Recent innovations in communications technologies have brought about enormous changes in the way we think, but at the same time there is more interest than ever before in traditional crafts and skills, including the craft of writing, or calligraphy. Calligraphy means beautiful writing and the word was coined only in the seventeenth century. Earlier, when writing was strictly a useful craft, the notion of associating it with beauty would probably have been regarded with some suspicion, although there is no doubt that fine writing and good scribes were highly esteemed. Then, as now, the act of writing was a very personal one; it involves movement and touch, a peculiarly direct expression of thoughts and feelings through words, by the control and manipulation of mind and hand, made permanent in the marks left by the simple tool which is the pen.

During the thousand years of the manuscript book and the five hundred of the printed book, letters have changed in dramatic and subtle ways. Until quite recently modifications usually come about slowly, for letters are essentially conservative (the letters on this page were developed and matured over a thousand years ago), their success measured by the skilfulness of the performance which produced them rather than by any radical treatment of their forms.

Tracing the alteration and changes in the appearance and use of written letters brings an understanding of the processes of historical movement, for letters often reflect, in the same way as other decorative and applied arts, the characteristics of particular places and time. Perhaps more important to artists and designers, the past is also a huge reservoir of visual ideas waiting to be discovered and reshaped to modern needs as well as providing a constant source of inspiration.

During the centuries following the death of Christ, the last centuries of the Roman Empire, the square capital letters of inscriptions were also used in books, although very few examples have survived. A narrower capital letter called rustic was also used in late Roman books, and one example was painted on a wall in the Italian city of Pompeii, destroyed in an earthquake in AD 79. Elements of the square capital letters were also visible, and both square capitals and rustic capitals were revived several times in later centuries.

Square capitals and rustic capitals were, when written in books, almost always used for pagan texts. The early Christians appear to have deliberately developed a different kind of letter to distinguish or separate themselves from the old order. Uncial letters were used for four or five hundred years, and Christianity, with its commitment to the Word as revealed through a book, would have needed many books of different kinds.

An important feature of most early surviving books is that they were written on parchment manufactured from the pelts of animals-sheep, calf and goat being the most common. Parchment was used for books and documents almost throughout the Middle Ages, since paper, introduced into Europe by the Arabs, was rare until the fifteenth century. When properly prepared, parchment is very receptive to quill pens, prepared from the primary flight feathers of birds. The basic characteristic of the broad-edged pen is clearly visible in the examples of uncial shown here (Plates 4,5), a gradual transition from thick to thin marks as the broad-edged nib held at a constant angle described curves. This thick-to-thin mark is the basis on which the peculiar beauty and form of Western calligraphy and letters depend.

The writing material of classical times was papyrus, manufactured from the stems of plants which grew in the River Nile in Egypt. The late Roman cursive shown here (Plate 1), made with a blunt pen fashioned from the stem of a reed, was written on papyrus. The cursive script is not easy to read, since its letters are very different from modern forms. But it is beautiful for its sense of line and movement and, when married to more formal scripts, formed the basis on which the letters we still use were developed.

With the fall of the Roman Empire, learning was to become centred from the sixth to twelfth centuries in monasteries, and nearly all books created during this period were made in monastic scriptoria. The varieties of uncial script gave way to a range of local scripts, rarely calligraphically interesting. It was not until the early ninth century that, along with reforms of many other kinds, a single script was adopted throughout Europe. This style grew out of the powerful influence of Charlemagne (who at the height of his power ruled much of what is now modern Europe) and his churchmen. The new script, the Carolingian minuscule (Plate 5), was employed in highly organized books, and both the script itself and the way in which it was used have profoundly influenced writing and book-making ever since. A careful distinction was made between individual letters, and the use of small letters with capitals, but the effect of the script depended as much on the articulation of the space within the page, from the space between words and lines, to the larger margins which surrounded text areas.

Not for another three hundred years were other scripts to be developed. These grew from the demands made by new kinds of books and documents and are associated with the rise of urban centres (including universities) and the decline of monasteries. The twelfth-century script in the monastic manuscript in Plate 7 may not look very like the mature Carolingian minuscule in Plate 6, but it is essentially Carolingian with obvious differences of size, proportion and general aspect.

The varieties of late medieval scripts may best be seen in the specimen sheet of a German scribe and teacher of writing (Plate 11). An almost bewildering range of specimens is shown and each has its specific use, from formal books to commercial documents. For from the thirteenth century onwards numerous scripts were needed for bureaucracies and commerce. Records and transactions were, for the first time since late antiquity, systematically written down. With this growth in record-keeping came a need for suitable scripts and a large number of scribes, for the typewriter was not to be invented until the nineteenth century.

During the later Middle Ages most lavishly decorated books were made for laymen or laywomen by urban-based professional scribes and artists. Plates 9 and 10 show two such manuscripts and both were written in the most formal of late medieval scripts. Curves were almost eliminated, and their effect depends upon the regular rhythm of black verticals and enclosed white spaces. The elimination of curved strokes may have been the result of streamlining production since it is easier to train a moderately skilled scribe to write letters composed of what are essentially straight lines than to form letters composed of thick-to-thin curved strokes. Manuscripts written in these kinds of scripts were especially appealing to Victorian tastes, and interesting parallels can be drawn between the weight of these letters and the bold letters used for ephemeral purposes in many nineteenth-century advertisements. Equally interesting are the visual parallels between late medieval script and modern sans-serif letters, the descendants of nine-teenth-century display types.

Rather different in its effect but, like the two manuscripts shown in Plates 9 and 10, made in northern Europe, is the manuscript shown in Plate 14 and used for some display work by modern scribes. It is, of all the late medieval bookhands, the most exot-ic in appearance and, unlike the script in Plates 9 and 10, has not yet become a visual cliché.

The manuscripts of the Italian Renaissance have been the most influential on printed books because they were perfected soon before the invention of printing from movable types. At a glance, without knowing that it was written, the fifteenth-century script in Plate 12 could almost be mistaken for printing, so close is its general appearance to the printed pages we are familiar with. The other great 'invention' of early printed books was the adaptation of a particular kind of script (with its origins in cursive scripts) now known as 'Italic' to accompany the 'Roman'. The script in Plate 16 is the ancestor of our Roman types and the compressed, pointed script in Plate 15 is the kind of script on which italic types were based.

The coming of printing obviously eliminated the need to write books by hand, although the printed and the manuscript book co-existed for about a hundred years, and the last manuscript books of the sixteenth century often closely imitated printed books in their letters. Over a period of about two generations there appears to have been a shift from a situation in which printed books imitated manuscripts to one in which manuscripts imitated printed works. The finest writing was by now usually to be found in documents, and especially in the hands of those who chose to write in an italic style. The decision to write such a hand was taken not so much for its aesthetic or practical qualities, although italic is both aesthetic and practical, but because it was used by the most advanced humanists and scholars of the Renaissance. Other kinds of hands were written in the sixteenth century, and these descended from the myriad of late medieval scripts shown in the rather earlier specimen sheet of scripts in Plate 11.

Gradually the range of scripts narrowed, so that by the end of the eighteenth century what is known as 'copperplate' or (in the United States) 'spencerian' was in use, with some local variations, throughout Europe, it was (and is) a script dependent for its effects on the pressure placed on the pen nib. Thick and thin strokes were not made with a broad-edged pen held at a constant angle, but by opening and closing the two points of a nib pressed hard or gently onto the paper. The technique was easily transformed into copperplate printing, in which plates were engraved, and the mutual influence of engraving and writing is very clear in the two late eighteenth-century examples of writing with printing shown in Plate 17

At the end of the nineteenth century the Arts and Crafts movement revitalized many traditional crafts, including calligraphy. The typical Victorian 'illuminated' writing showed how distant and remote the crafts of writing and illumination had become from their medieval predecessors. The concern of the great artist-craftsmen of the Arts and Crafts movement, of whom William Morris was the most seminal figure, was to try and restore artistic credibility to the work of craftsmen by reinvestigating the principles of the work of their medieval predecessors. Morris himself was interested in calligraphy and made some calligraphic manuscripts partly based upon his study of sixteenth-century writing manuals such as that of Arrighi, some of whose work is shown in Plate 15. Morris also collected medieval manuscripts, but the attention he devoted to calligraphy, lettering and type design was only one among a wide range of activities. The interest in formal writing and calligraphy that he inspired bore fruit in the work of Edward Johnston. Although Johnston worked after Morris had died, Morris's ideals were the foundation of Johnston's life work.

In 1906 Johnston published *Writing and Illuminating and Lettering*, the bible of calligraphers which has never since been out of print. Johnston's own work was to articulate clearly the importance of the broad-edged pen in fine writing, and early in his career he spent much time looking at, and analysing, medieval bookhands. But it was the Anglo-Caroline hand that interested him more, for he saw its fitness as a model and its suitability as a basis for individual development. Johnston's own work ran roughly the same course as medieval writing: early in his career he worked with uncial-type hands, later with Anglo-Caroline hands and, at the end of his career, with rather more

compressed hands, similar in their general principles to late medieval bookhands. Johnston's best work has a taut elasticity and was rarely decorated except for variation of the size of letters and the use of red with black.

Johnston's writings and designs had a wide influence, not only in England but also in Europe. But while his work has a certain power of conviction and majesty about it, his followers in England mostly trivialized his teaching and output by failing to understand that he was primarily concerned with trying to establish principles. It was this concern of Johnston's that led him to design one of the most seminal of printed letters, the alphabet he created for London Transport (still in use), which profoundly influenced modern sans-serif type design.

Johnston's work was better understood in Germany, and there the teaching of lettering was less eclectic and more determinedly modern. The writing of Rudolph Koch (Plate 18) illustrates this perfectly, as a comparison of his work with the kind of writing on which it was modelled (Plates 8 and 9) reveals. Koch was very influential as a teacher and he also designed many typefaces.

Since the work of the pioneer scribes of the first part of the century, much of the most interesting work with texts and words has been made by painters. Two examples are shown here, one by Paul Klee, the other by David Jones (Plates 19 and 20). Their attitudes towards the text have been very influential in the last part of the present century, for the best work of modern scribes lays as much emphasis on the words themselves as on the manner in which they execute letters. Although a great deal of modern work is concerned with performance and the display of manual skills (dreary alphabets saying nothing, for example), anticipated only in part by the serious enquiry of such artists as Arnold Bank (Plate 21), the most interesting work is that in which content matters over and above execution.

The work of Ann Hechle (Plate 22) is not merely fine writing, but fine thinking about the nature and meaning of the words written. The large and elaborate piece shown here was considered over a period of years, and in it are to be found not only the results of her searching for suitable arrangements of her texts, but also their relationship to one another in what they say. The whole depends for its effect not only upon the scribe's skills but also upon her sense of content and rhythm (owing something to interval in the musical sense).

If the work of Ann Hechle is essentially verbal, that of Thomas Ingmire, in particular his recent output, is essentially visual (see Plate 26). Ingmire is no less concerned with the content of the words and texts with which he works than Hechle, but the richness of the painted surface and the integration of visual and verbal elements represents an interest which modern scribes and artists have only recently begun to explore. Different mixtures of attitudes towards the making of lettered pieces may be seen in the work of the two other modern scribes shown here, Susan Skarsgard and Charles Pearce.

The richness of the modern work shown here has not grown from nothing. It is rooted not only in a profound knowledge of the traditional tools and techniques of the scribe, but also in the eclectic, even iconoclastic, attitudes long held by modern artists which are new to scribes and those who use the texts of others as their subject matter. More traditional work will continue to be made, but it is the recent movement towards expression rather than interpretation that is giving work written with pens its peculiar vigour and vitality. This is not a new thing, for centuries ago Eadfrith, the scribe and artist who executed the *Lindisfarne Gospels* (Plate 2) fused verbal and visual elements in his work. Few would deny that the Lindisfarne Gospels form one of the supreme works of art, and the best work of Eadfrith's modern successors is returning to his preoccupation with and concern for the apt presentation of the work of others.

No complete history of calligraphy and lettering can be revealed by the twenty-six plates here. The selection is a personal one and includes some of the very finest work of the Middle Ages as well as some virtually unknown work which ought to be of interest to all those concerned with writing and lettering. If there is a bias, it has been towards English work which I (the author) know and love best. The format and size of this book has allowed much of the work to be shown at actual size, including the margins of pages. For ultimately the effect of writing does not depend on the manner of the execution of the strokes, whether made with pen, reed or brush, but on the spaces between them. It is the analysis of this, and the other formal elements that make up writing, which are the most useful to observe, for it is the principles to be discovered in the work of our ancestors which will best help us to understand it, and, most importantly, which will help us to see the world about us with new and better vision.

MICHAEL GULLICK

PLATE 1

ROMAN CURSIVE SCRIPT

572 AD

Rapidly written Roman cursive script, using a reed pen on papyrus. The letters may appear illegible to modern eyes, but they contributed to the forms of the small letters in use today. The line and movement in this piece of writing are close to some oriental calligraphy and modern drawing and have similarities with certain kinds of modern calligraphy (see Plates 23 and 26).

Courtesy of the British Library, London (Add 5412).

PLATE 2

THE OPENING TO THE BOOK OF LUKE FROM THE LINDISFARNE GOSPELS

c. 698, England

The Lindisfarne Gospels were made in about 698 at Lindisfarne off the Northumberland coast. The writing and decoration of the manuscript are believed to be the work of Eadfrith (Bishop of Lindisfarne 698-721). The page is remarkable for the exactness of the execution (mostly made with a pen over a preparatory layout) as well as for the articulation and clarity of the verbal and visual elements. The different kinds of letters, diminishing in size from the large Q, are typical of the Irish (Insular) manuscripts of this period and this is a device that was to be used throughout the Middle Ages. The decoration, almost purely abstract, owes virtually nothing to the classical world, and is especially appealing to modern sensibilities familiar with non-figurative painting.

Courtesy of the British Library, London (Cotton Hon Nero D iv).

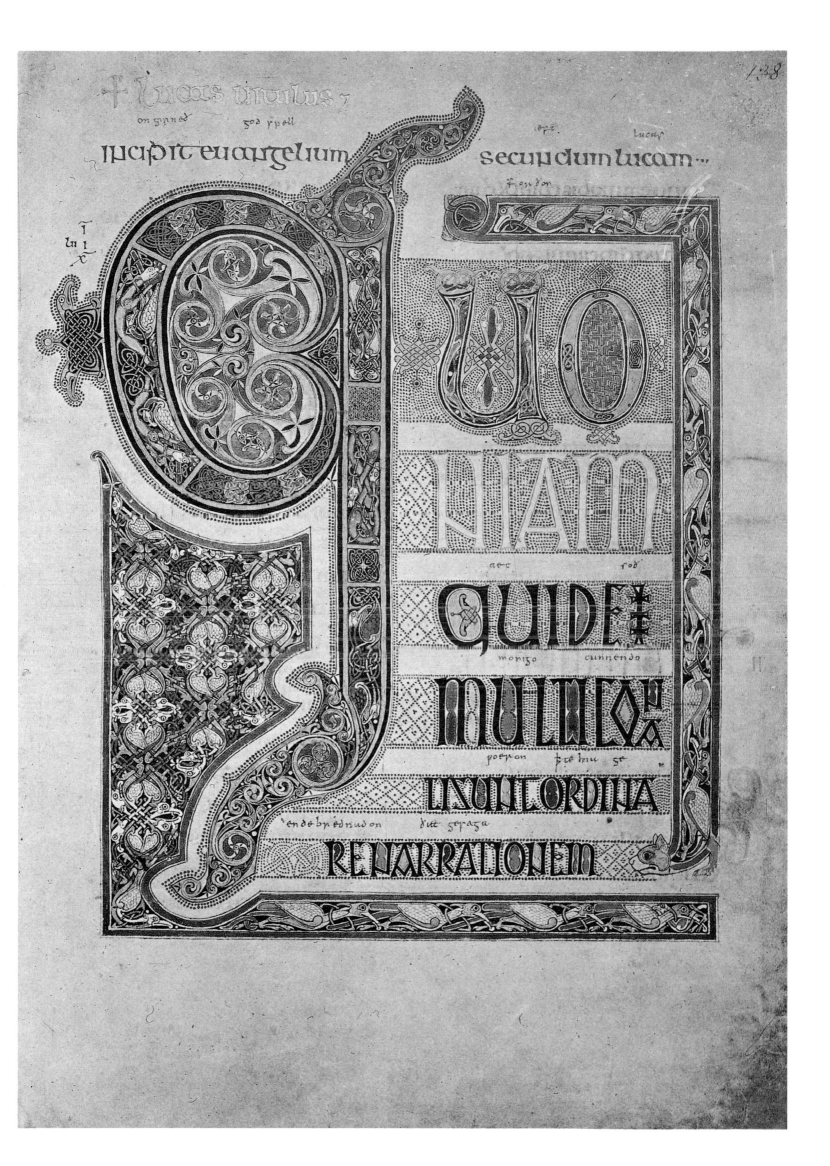

INCIPIT EUANGELIUM SECUNDUM LUCAM

QUO
NIAM
QUIDEM
MULTICON
LISUNTORDINA
RENARRATIONEM

PLATE 3

THE RULE OF ST BENEDICT

Early eighth century, England

The manuscript contains the *Rule of St Benedict,* the fundamental guide to monastic life for most of the Middle Ages. The manuscript is the only surviving example of the text in uncial letters as well as the oldest known copy of the text. There are no illustrations and the only decoration comes in the red titles and the black and red initials outlined with dots (an Insular practice, see Plate 2). The uncial are heavy in weight and there is little or no space between the words. The effect of the page, with its generous margins, wide space between the columns and generous interlinear space, is majestic.

Courtesy of the Bodleian Library, Oxford (Hatton 48).

XV ALLELUIA TENEATUR
QUIBUSTEMPORI
BUSDICATUR
A co pascha
usquepen
tecosten
SINEINTERMISI
ONEDICATUR AL
LELUIA TAM IN
PSALMISQUAM
INRESPONSORI
IS APESTICOSTEN
AUTEMUSQUE
INCAPUDQUADRA
GENSIMAEOM
NIBUSNOCTIB3
CUMSEXPOSTE
RIORIBUSPSAL
MISTANTUMAD
NOCTURNASDICA
TUR OMNIUERO
DOMINICAEXTRA

QUADRAGENSIMU
CANTICAAMATU
TINISPRIMATER
TIASEXTANONA
qu ecumALLELU
IADICANTUR
UESPERAIAMAN uero
TEFANA RESPON
SORIAUERONUM
QUAMDICANTIR
CUMALLELUIA
NISIAPASCAUSQ
ADPENTICUSTEN
QUALITERDIUINA
OPERAPERDIEM
AGANTUR
Ut AITPROFE
TA SEPTIES
INDIELAUDE
DIXITIBI QUISEP
TINARIUSSACRA
TU NUMERUS

PLATE 4

THE VESPASIAN PSALTER

Mid-eighth century, England

The full-page illustration shows David with his scribes and musicians and is probably derived from Mediterranean models, although the frame and arch contain Insular motifs (see Plate 2). The initial D is followed by a line of rather dull letters against a lively coloured background, leading into the text. The script is a very expert late uncial, and the interlinear gloss was added in a good hand about a hundred years after the manuscript was made.

Courtesy of the British Library, London (Cotton Vesp Ai).

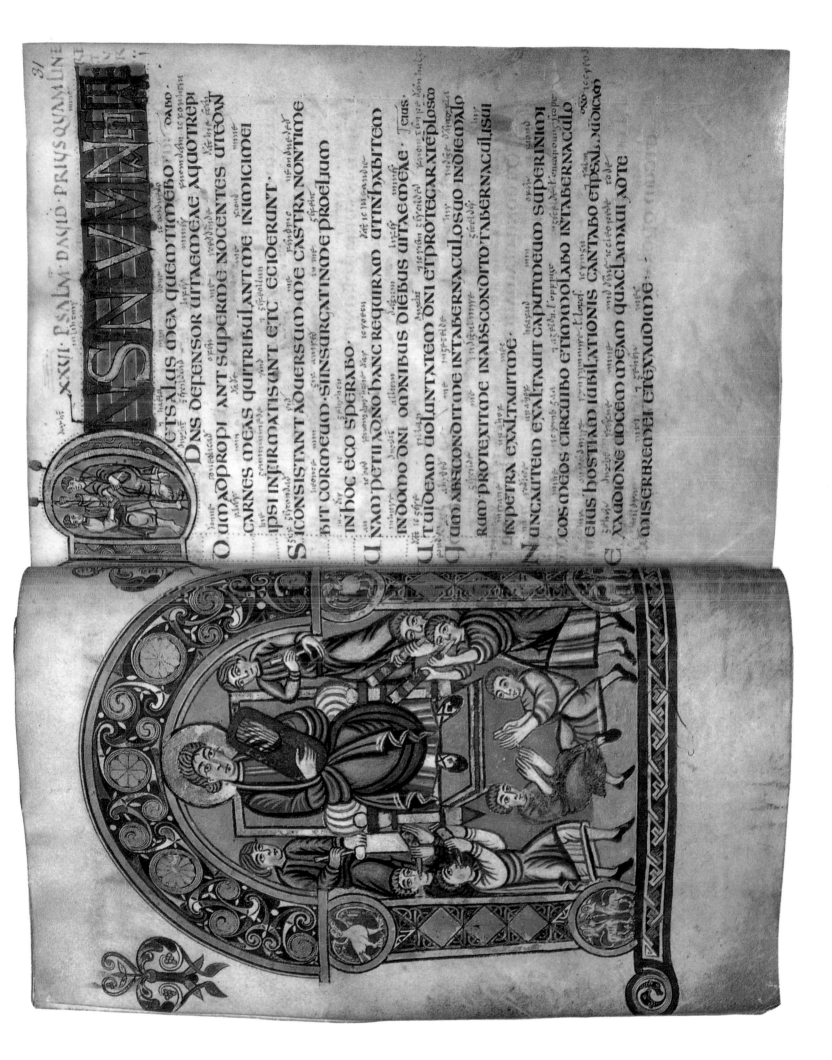

xxvii· PSALM· DAVID· PRIVSQVAM LINE[retur]

DNS ILLVMINATIO

ET SALVS MEA QVEM TIMEBO· DABO·
DNS DEFENSOR VITAE MEAE A QVO TREPI[dabo]

DVM APPROPIANT SVPER ME NOCENTES VT EDANT
CARNES MEAS QVI TRIBVLANT ME INIMICI MEI
IPSI INFIRMATI SVNT ET CECIDERVNT·
SI CONSISTANT ADVERSVM ME CASTRA NON TIMEBIT
COR MEVM· SI INSVRGAT IN ME PROELIVM
IN HOC EGO SPERABO·

VNAM PETII A DOMINO HANC REQVIRAM VT INHABITEM
IN DOMO DNI OMNIBVS DIEBVS VITAE MEAE· Ieius.
VT VIDEAM VOLVNTATEM DNI ET PROTEGAR A TEMPLO SCO
QVIA ABSCONDIT ME IN TABERNACVLO SVO IN DIE MALO
RVM· PROTEXIT ME IN ABSCONDITO TABERNACVLI SVI

IN PETRA EXALTAVIT ME·

NVNC EXALTAVIT CAPVT MEVM· SVPER INIMICOS
MEOS CIRCVIBO ET IMMOLABO IN TABERNACVLO
EIVS HOSTIAM IVBILATIONIS CANTABO ET PSALMVM DICAM
EXAVDI DNE VOCEM MEAM QVA CLAMAVI AD TE
MISERERE MEI ET EXAVDI ME·

PLATE 5

THE BEGINNING OF AN OLD TESTAMENT BOOK

Mid-ninth century, France

From a huge ninth-century French Bible, the text is a fine Carolingian minuscule very close to the printed letters used today. The left column is the end of the chapter titles (a kind of contents list) and is concluded with a line of rustic capitals. At the head of the second column are two lines of capitals similar to inscriptional capitals, and following the initial D is a line of uncial. The clarity of the design of the page is striking, including the use of the running titles at the head. The figure in the initial D is reminiscent of classical figures, but the interlace in the stem is purely Insular.

Courtesy of the British Library, London (Add 10546).

EXPLICIUNT CAPITULA

INCIPIT LIB SAPIENTIAE

D ILICITE IUS titiam qui iudicatis terram. sentite de dno inbonitate et insimplicitate cordis quaerite illum. Qnm inue niatur ab his qui non temptant illum. Apparet autem eis qui fidem ha bent in illum. per uersae enim cogita tiones separant a do. probata autem uirtus. cor ripit insipientes. Qnm in maliuola anima non in troibit sapientia. nec habitabit in corpore subdito peccatis.

II Scs enim sps disciplinae effugiet fictum et auferet se a cogitationib; quae sunt sine intellectu. et cor ripietur a superueniente iniquitate. Benignus e enim sps sapientiae. et non liberabit maledictum a labiis suis. Qnm renum illius testis est ds et cordis eius scrutator. e uerus. et linguae illius auditor. qnm sps dni repleuit orbem terrarum. et hoc quod continet omnia scientiam habet uocis. propter hoc qui loquitur iniqua non potest latere. nec praeteriet illum corripiens iudicium. In cogi tationib; enim impii interrogatio erit. sermonu autem illius auditio ad dm ueniet. et ad correp tionem iniquitatum illius. qnm auris zeli audit omnia. et tumultus murmurationum non abscondet.

III Custodite ergo uos a murmuratione quae nihil pro dest. et a detractione parcite linguae. qnm ser mo obscurus in uacuum non ibit. Os autem quod mentitur occidet animam. Nolite zelare morte in errore uitae uestrae. Neq; adquiratis perditionem in operib; manuum uestrarum. qnm ds mortem non fecit. nec laetatur in perditione uiuorum. Creauit enim ut essent omnia et sanabiles fecit nationes orbis terrarum. Non e in illis medica mentum extermini. nec inferorum regnum in terra. Justitia perpetua e et inmortalis. im pietatem manib; et uerbis arcessierunt illam. et aestimantes illam amicam defluxerunt. et sponsionem posuerunt ad illam. qnm digni sunt qui sunt ex parte illius.

PLATE 6

AN EXAMPLE OF ANGLO-SAXON WORK

Late tenth century, England

The interlace forming the Q from this large Psalter is typical of tenth-century Anglo-Saxon work, as are the animal head terminations. The coloured lines of pen-drawn capitals (the colours and colour sequence are possibly the house style of the scriptorium where the manuscript was made rather than the choice of the artist) diminishing in size down the page to two lines of rustic capitals, are as deliberate as the articulation of the elements in some of the earlier manuscripts shown here (see Plates 2 and 5 for example) if less crisp in the density and richness of elements. The lines of writing at the head of the page were written in a script looking like a cross between the script of the *Lindisfarne Gospels* (Plate 2) and Carolingian minuscule (Plate 5).

Courtesy of the British Library, London (Add 37517).

in fine psalmus dauid cum ustit adeu doech
idumeus· et annuntiauit paul
et dixit ei ustit ad indomo
 achimelech·

RIARIS IN

MALITIA·QVIPOTENS

ESININIQVITATE·

TOTADEINIVSTITIAEGITAVIT

LINGVATVA·SICVTNOVACLA

Acuta fecisti dolum·

Dilexisti malitiam super benignitatem ·

PLATE 7

A MONASTIC MANUSCRIPT

Mid-twelfth century, England

The narrow proportion of the script here, roundish in its general aspect, is midway between the smaller Carolingian minuscule shown in Plate 5 and the angular compression of late medieval formal bookhands, as shown in Plates 8 and 9. The size of the manuscript and its two-column format are typical of twelfth-century monastic book production, and manuscripts like this were made in thousands all over Europe. This English example is known to have been written by a professional scribe and his hand is very smooth and fine. The superb B, almost entirely executed with a pen over an underdrawing, was made by another hand.

Courtesy of Jesus College, Oxford (Jesus 63).

an ñ offendit in pncipiu serie; ꝛ
manserit ieo cui reposita mane
bant oĩa. & ipſe erat ſpeſ gentiu.
hinc ꝗd ſumma exordiu. tꝛp̃ ꝓloꝰ
Jncipit lib̃. I.

BELLO PARTHICO Qd

ꝗⁱſſ ͬ oꝛ macħabeos duceſ geꝛ
temꝗ; medox diuturnum ac
frequenſ. uariaꝗ; uictoria fuit.
incentiuu p̃cipuu dedit ſacri
legii dolor: ꝗa rex antiochuſ
cui nom̃ illuſtris. antiochi re
giſ fili. ubi egyptu ꝗꝗ; ſuo
impio adiunxit. in ſupbiã
elatuſ ꝗd a incerta belloꝛ
proſpauiſſent: ꝛ ꝛ͂ hebreoꝛ
negligi miniſteriaꝗ; eoꝝ
profanari iuſſerat. id ꝗ; po
ſtulantibꝰ pleriſꝗ; iudeiſ ſta
tuere auſuſ. ꝗd factu matha
thiaſ ſacerd os ꝓꝑtu nequiⁱ.
nec ſolu ipſe temꝑauit a
ſacrilegio. regaliꝗ; edicto ñ
obtẽpauit uerũ etiã immo

lante ſimulacriſ hoſtiaſ de
poptaribꝰ ſuiſ nactuſ. gla
dio tꝛſuerberauit: & congre
gata manu atꝗ; aſſidens inſo
cietate aſcitiſ. ipſe cu filiiſ
ſuiſ temeꝛantes uſũ patriu
& iuſtitiaſ legiſ. alioſ neca
uit. pleroſꝗ; expulit. belliꝗ;
ſabbato adoriendi auctor fu
it. ne ſimili arte ipſi ꝗqꝗ; de
ciperẽ: ſic iam pleriꝗ; eorum
dum ſabbato bellu ſuſcipere
detrectant. irruentibꝰ in ſe
hoſtibꝰ multi occubuere. Po
tentiã p̃ſp̃i actuſ dederunt.
& pſeueꝛauit in uiuo uſꝗ; ad
extꝛiũ uite ſtudiũ defenſioniſ.
& pietatiſ uigor. Sed cum
ſibi ſupm̃u diem ad eſſe intel
ligeret. uocatiſ ciuibꝰ atꝗ; aſ
ſiſtentibꝰ liberiſ: hortatuſ eſt
ut tuerent̃ patriã templiꝗ; re
ligionẽ. duceq; iis iudam ma
chabeu cuꝛe ac ſollicitudiniſ
ſue ſucceſſorẽ reliꝗt. ꝗ bello
ſtrenuuſ. conſilio bonuſ. ac
p̃cẽtiſ fide. pmpuſ. ꝗm fre
quenter innumeraſ hoſtium
copiaſ parua manu fudeꝛt.
pſequi ñ eſt p̃ſentiſ neg̃otii.
ꝗd tam breui colligere datuꝛ.
ꝗd ſepe p̃ſp̃iſ uſuſ ſucceſſibꝰ
excitauit in ſe magnã hoſtiu
multitudinẽ: ꝗ artifuſuſ ſun

PLATE 8

A MEDIEVAL PSALTER

Early fourteenth century, England

The monumental late medieval bookhand shown here was produced by the almost total elimination of curved strokes. But see how the slight curvature to many of the smaller diagonal strokes relieves what would otherwise be a monotonous pattern. The dense, regular texture of the writing acts as a foil to the surrounding decoration which, despite being dazzling to the eye was made to easily identifiable formulae ('colouring by numbers'). Some of the marginal figures are bizarre (known as grotesques), but the standing knight holding up a shield was no doubt connected to the manuscript's first owner, a member of a rich baronial family.

Courtesy of the British Library, London (Add 49622).

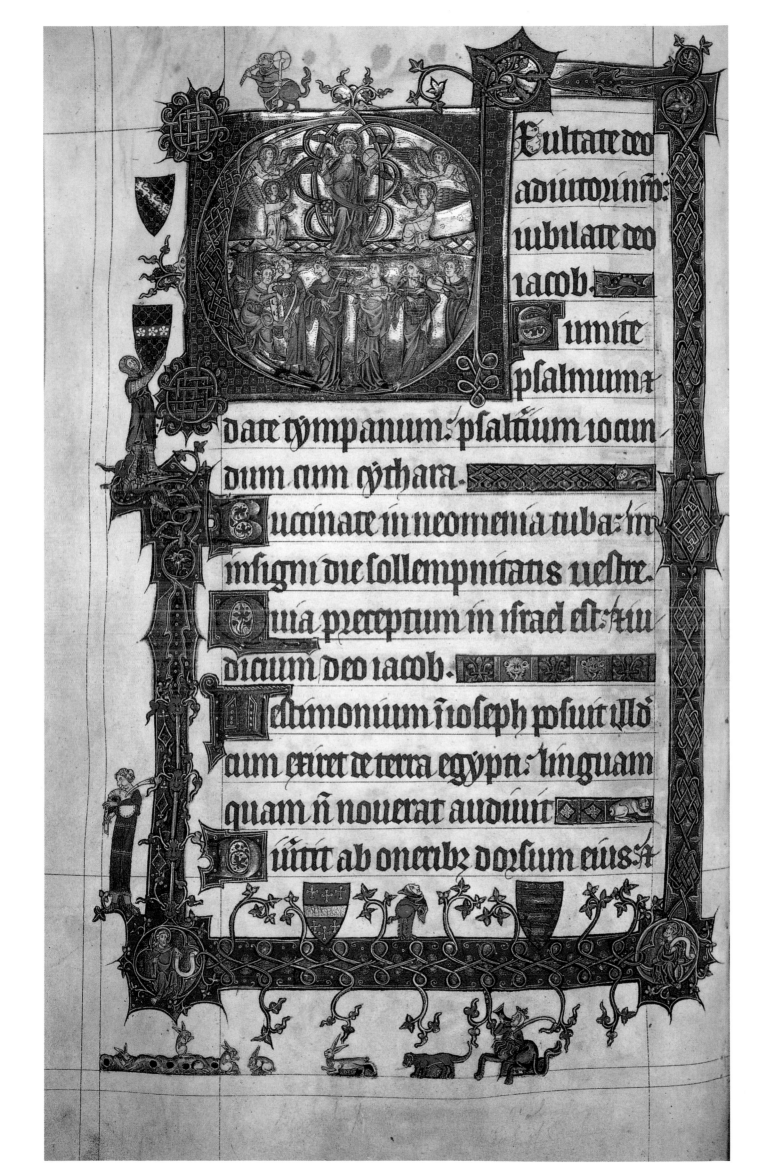

PLATE 9

A DECORATED MANUSCRIPT

c. 1340, England

In this plate the minims have square terminations at the feet. The fine lines used to finish many of the letters were made with the corner of the quill. The red pen work around the small initial letters was rapidly executed (possibly by a specialist) with great delicacy. The peculiar decoration, ranging from a carefully observed travelling carriage (other horses which pulled it are in the margin of the facing page) to the grotesques, is apparently quite unconnected to the text and used purely for ornamental purposes.

Courtesy of the British Library, London (Add 42130).

tum nostrum.

Recordatus est quoniam puluis sumus: homo sicut fenum dies eius tanquam flos agri sic efflorebit.

Quoniam spiritus pertransibit in illo ꝉ non subsistet: ꝉ non cognoscet amplius locum suum

Misericordia autem domini ab eterno: ꝉ usque in eternum super timentes eum

Et iusticia illius in filios filiorū: hiis qui seruant testamentum eius.

Et memores sunt mandatorum ipsius: ipsius: ad faciendum ea.

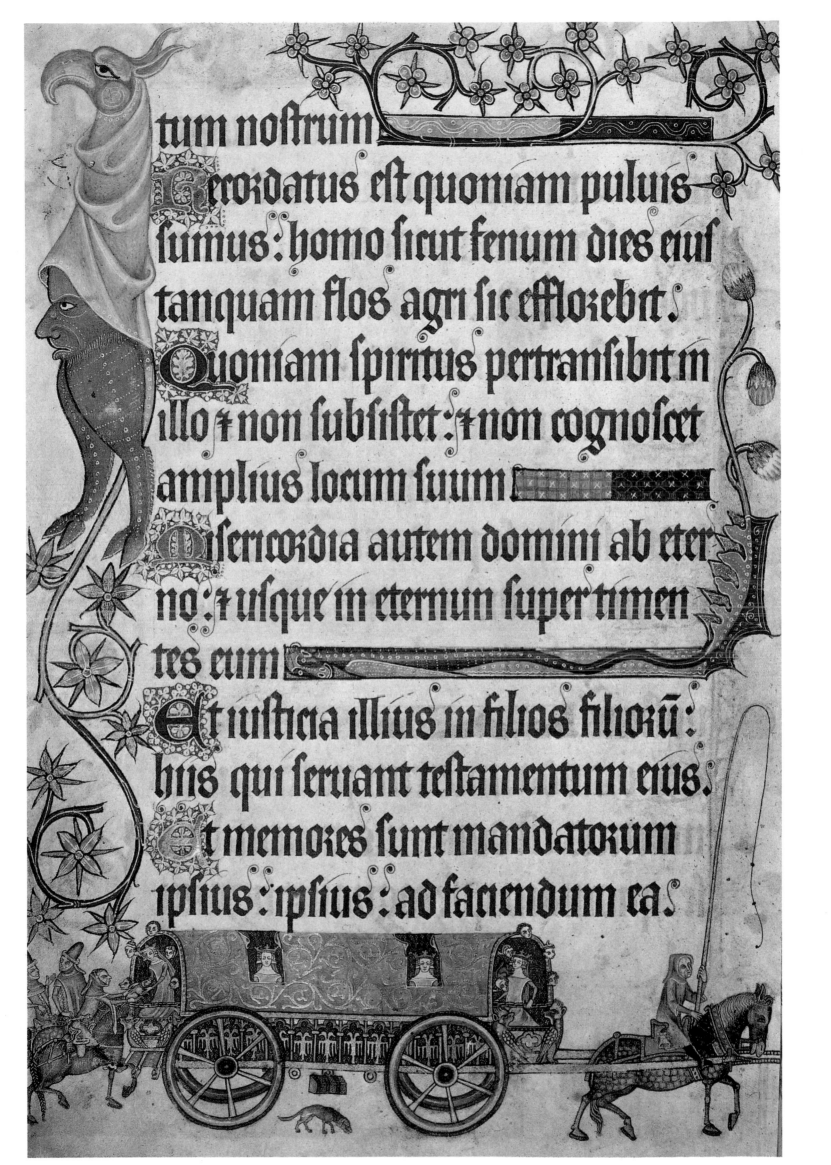

PLATE 10

DIAGRAM ILLUSTRATING MEDIEVAL RELIGIOUS THOUGHT

Late fourteenth century, England

The diagram shown here occurs in the middle of a religious poem in an enormous manuscript containing a vast collection of English poetry. The first column gives the petitions of the Lord's Prayer (in Latin) with an English translation in the roundels underneath. The piece then has to be read horizontally with the petitions leading, through the maze of decorative panels, to columns listing, first, religious truths, secondly, the virtues, and, at the right, the vices. The content and format are typical of religious thought and attitudes during the late Middle Ages, here brilliantly realized in visual form.

Courtesy of the Bodleian Library, Oxford (Eng poet a I).

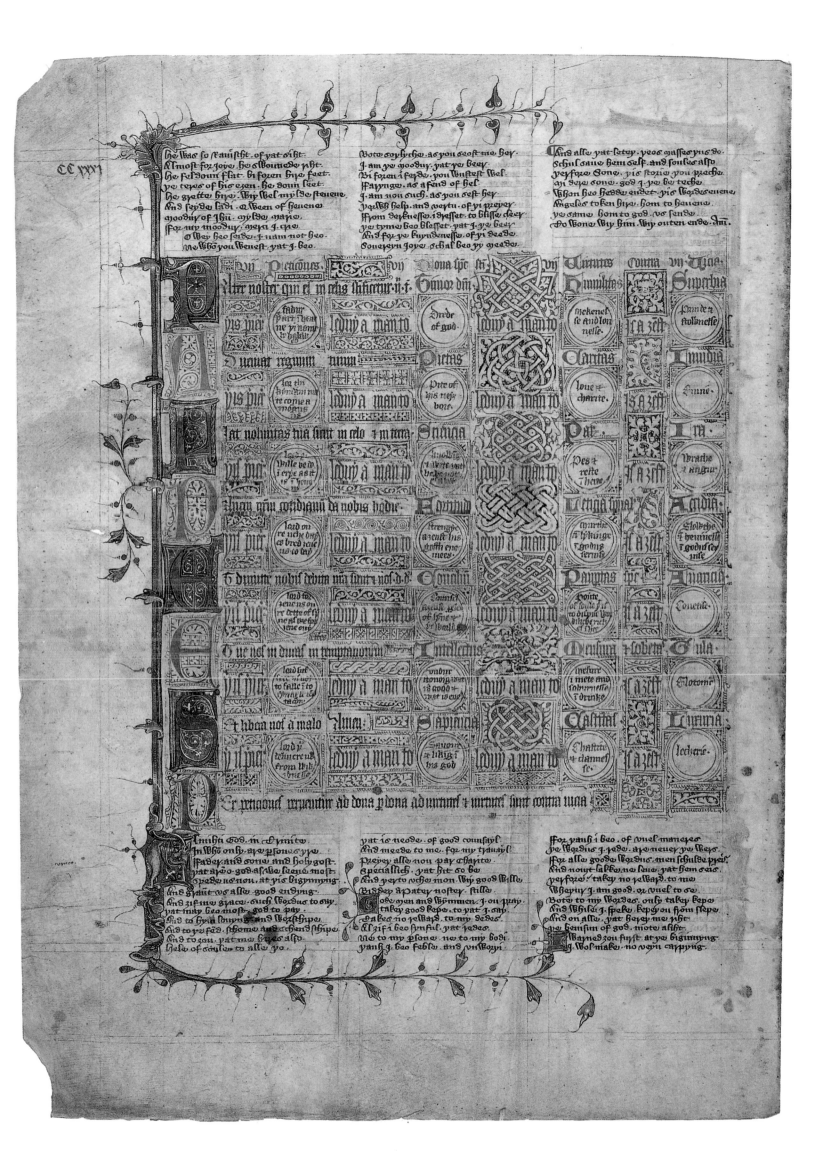

PLATE 11

A SHEET SHOWING THE VARIOUS STYLES OF SCRIPTS IN USE IN THE LATE MIDDLE AGES

c. 1400, Germany

The sheet would have been displayed in a public place to advertise the work of its scribe-teacher. The passage at the lower right declares that all those who wish to be instructed in different styles of writing should come to the scribe Johann van Haghen, who assures potential students that they will be able to learn quickly and for a fair price.

Courtesy of the Staatsbibliothek, Berlin (Lat fol 384).

Beatus vir qui non abiit in consilio impiorum et in via peccatorum non stetit et in cathedra

Verba mea auribus percipe domine intellige clamorem meum intende voci orationis meae

Nottula Nottula simplex

Nottula acuta

Semi quadratus Semi quadratus

Cum invocarem exaudivit me deus iustitie mee in tribulatione dilatasti michi miserere mei et exaudi orationem meam

Textus Rotundus

Quare fremuerunt gentes et populi meditati sunt inania Astiterunt reges terre et principes convenerunt in unum adversus dominum et adversus

Nottula Nottula fracturarum

Argentum

Nottula gelauata

Septenus

Argentum extra penam

PLATE 12

A LARGE RENAISSANCE MANUSCRIPT

Mid-fifteenth century, Italy

Quite different from the late medieval books of northern Europe (Plates 8 and 9) the small script was based upon earlier models to revive the clarity of such Carolingian books as shown in Plate 5. The modern look to the letters is due to the fact that some early printers based printing types on script like this - the direct ancestors of the letters you are now reading. A great deal on this page owes much to the past and the perception that Italian Renaissance scribes, artists and patrons had of classical Rome. The lines of capital letters at the head of the page and the carefully constructed large initial G reflect the proportions of Roman inscriptional letters. The dense border is a mixture of flat, decorative motifs pierced by little pictures receding away from the surface plane of the page.

Courtesy of the British Library, London (Add 15246).

LORIOSISSIMAM CIVITATEM DEI
SIVE IN HOC TEMPORVM CVRSV CVM
inter impios peregrinatur ex fide uiuens siue
in illa stabilitate sedis eternae: quam nunc expe
ctat per patientiam: quoad usq; iustitia conuerta
tur in iudicium: deinceps adeptura per excellentia
uictoriam ultimam & pacem perfectam: hoc opere
ad te instituto & mea ad te promissione debito de
fendere aduersus eos qui conditori eius deos suos p
ferunt fili carissime marcelline suscepi. Magnum
opus & arduum: sed deus adiutor noster est. Nam scio quibus uiribus opus sit:
ut persuadeatur superbis quanta sit uirtus humilitatis: qua fit: ut omnia terre
na cacumina temporali mobilitate nutantia non humano usurpata fastu, sed
diuina gratia donata celsitudo transcendat. Rex enim & conditor ciuitatis hu
ius: de qua loqui instituimus: in scriptura populi sui sententiam diuine legis ape
ruit: qua dictum est. Deus superbis resistit: humilibus aut dat gratiam. Hoc ue
ro quod dei est superbe quoq; anime spiritus inflatus affectat: amatq; sibi in lau
dibus dici: Parcere subiectis & debellare superbos. Vnde etiam de ciuitate terre
na: quae cum dominari appetit: & si populi seruiant ipsa ei dominandi libido do
minatur: non est pretereundum silentio quicquid dicere suscepti huius operis ra
tio postulat & facultas datur. Ex hac nanq; existunt inimici: aduersus quos de
fendenda est dei ciuitas: quorum tamen multi correcto impietatis ciues in ea fiut
satis idonei: multi uero in eam tantis exardescunt ignibus odiorum: tamq; mani
festis beneficiis redemptoris eius ingrati sunt: ut hodie contra eam linguas non
mouerent nisi ferrum hostile fugientes in sacratis eius locis uitam de qua super
biunt inuenirent. An non etiam illi romani christi nomini infesti sunt: quibus
propter xpm barbari pepercerunt? Testantur haec martyrum loca & basilice apo
stolorum: quae in illa uastatione urbis ad se confugientes suos alienosq; receperut.
Hucusq; cruentus seuiebat inimicus: ibi accipiebat limitem trucidatoris furor: illo
ducebantur a miserantibus hostibus: quibus etiam extra ipsa loca pepercerant: ne
in eos incurrerent qui similem misericordiam non habebant: qui tamen etiam
ipsi alibi truces atq; hostili more seuientes: postea q ad loca illa ueniebant: ubi fue
rat interdictum quod alibi iure belli licuisset: tota feriendi frenabatur imma
nitas & captiuandi cupiditas frangebatur. Sic euaserunt multi qui nuc xpianis

PLATE 13

A MANUSCRIPT FROM THE HAND OF BARTOLOMEO SAN VITO OF PADUA

1497-99, Italy

It is possible that this manuscript was written and decorated by the same hand, an unusual occurrence in the late Middle Ages and early Renaissance. Certainly the scribe of the manuscript was Bartolomeo San Vito of Padua, who spent a long period of time working in Rome. His pen-written coloured capital letters, based on late Roman inscriptional letters, are very distinctive, especially the A and V which always appear to lean slightly backwards. The two lines of writing at the foot are in San Vito's informal script and appear almost to have been 'drawn' rather than written, so carefully were the individual letters spaced out. The surface of the flat page is broken by the miniature, but all the visual elements, lettering, miniature, initial and frame lie harmoniously together. The cutting of the tail of the Q in the initial and its placement under the letter is a gentle humorous touch.

Courtesy of the British Library, London (King's 24).

P·VIRGILII MARO
NIS GEORGICON
LIBER·I·
AD MECAENATEM

VID FAC
AT LAE
TAS SE
GETES;·

QVO SIDERE TERRA

Vertere mecænas: ulmisq. adiungere uites
Conueniat: quæ cura boum: qvis cultus habendo

PLATE 14

A PAGE OF ROMANCE AND CHIVALRY PENNED AND ILLUSTRATED

c. 1490-1500, Low Countries

From a manuscript of one of the most lavishly illustrated copies of a popular chivalric romance. There are a number of quite distinct elements as in the Italian pages in Plates 12 and 13. It is dominated by the large miniature which appears as a window into a distant and remote world inhabited by figures whose sole preoccupation was pleasure. If it appears like that now, this is also how it would have appeared to contemporaries. The flat border, with carefully observed natural life depicted, encloses the whole, not only the miniature but also the rather dull initial and an area of writing. The script is called batard and is a curious mixture of formal and informal elements. It is very clearly pen-made and calligraphically interesting for its powerful sense of touch.

Courtesy of the British Library (Harley 4425).

Sses y fery et
furtay·
Et mainteffois
Je escoutay
Se ie orroye seans mille ame
Le truchet qui estoit decharme
Me ouurit vne pucellette
Qui asses estoit comte et nette
Et cheuaulx eut blonc come vng bassi
La chair plus tendre q vng poussin

Front reluifant fourcaz voultie
Lentreœil si nestoit pas vetis
 Amefut assez manet y mefure
Lenes eut bien fait a droiture
Les yeulx eut vers come faulcone
Pour faire enuie atoute gome
Doulce alaine eut et fauouree
La face blanche et couloure
La bouche petite et groffette
Et au menton vne foffette

PLATE 15

MANUSCRIPT IN THE ITALIC HAND BY ARRIGHI

c. 1509-17, Italy

This manuscript was made in Italy for presentation to King Henry VIII. It was almost certainly written by Arrighi, a scribe who worked in the Papal Chancery and who is famous as the author of the earliest illustrated printed writing manual. The manual taught the student what has become known as italic and this is the hand used in the manuscript shown here.

Courtesy of the British Library, London (Royal 12 C viii).

**PANDVLPHI
COLLENVCII PISAVRENSIS
APOLOGVS:
CVI TITVLVS
AGENORIA**

NER
tiam natu in
ter filias mi
norem, fatuã
alioquin atq̃
instrenuam

fœminam, Sed cui blanda species atq̃ al-
lectrix esset, labori, commun gentium
Deo, Orcus pater vxorem dedit. In=
gentes (ut est locuples deus) dotis nomi-
ne diuitias pollicens, si ex ea liberos gi=

AR
GVMEN
TVM

M urcea Ignauiæ et Inertiæ: Age-
noria vero Diligentiæ atq̃ Negocij
præsides Deæ, Romanis olim cul-
tæ: Sed et omnium mortalium vi-
tam pro cuiusq̃ studijs distinguen=
tes, huic Apologo materiam præbét:
quo Inertia, Fraus, Hypocrisisq̃
taxcantur,

Labor vero Virtus, et Ars extollun=
tur, et Iouis decreto rerum mu-
tatio portenditur.

PLATE 16

AN ALPHABET

c. 1529, Germany

The alphabet here is largely pen-drawn except for the simple pen-written letters. The washed drawings surrounding the letters are very delicate in their execution.

Courtesy of the British Library, London (Add 31845).

PLATE 17

TWO EXAMPLES OF WRITING FROM THE LATE EIGHTEENTH CENTURY

1781 and 1791, England

The variety of scripts that existed in the late Middle Ages (see Plate 11) gradually became reduced and narrower in range. Here is shown the contrast that existed between the hands of clerks and highly wrought printed letters (engraved and printed from copper plates) and charming headpieces. For much of the century, the teaching of writing had been and was to continue to be directed, as the books and advertisements of the teachers tell us, to those who worked in business and commerce. The Industrial Revolution demanded huge amounts of paperwork, all needing to be written out by hand. Fine writing was certainly a useful social grace but by now very much a minor one, which, however, perfectly reflected the spirit of its times.

Private Collection.

Richard Warren ~ PERFUMER,

at the Golden Fleece in Mary le Bonne Street, Golden Square, fronting Great Marlborough Street, Carnaby Market.

London

Imports, Makes & Sells

all sorts of the Richest Perfumery Goods, &c.

Dr. Crofft Coope London 12 May 1781.

Bot. of R. Warren.

3 Bot. Milk of Roses 10. 6
2 Do. Essence Musk 4. 5
1 Do. Oil of Jessamine 8. 5

£ 1 . 2 . 0

Recd. at the same time the Contents

R. Bofil.

for J. H. Warren

KING'S.

Bot. of Thomas King, William King & Co.

MERCERS to his MAJESTY.

their Royal Highnesses the Prince of Wales, Prince Frederick, Prince's Royal, &c. &c.

At the Wheat Sheaf, Henrietta Street, Covent Garden, London

		£	s	d
17	Rich Black Sattin	8/6	7 . 4 . 6	
22¼	Rich Black white striped Persian	10/6	13 . 1 . 6	
14	Rich Persian white Sattin	7/6	5 . 5 . 0	
1b	Unwrought white Sattin	7/6	1 . 10 . 0	
13½	White Sattin Persian	10/6	7 . 1 . 9	
3¾	White Persian	5/6	10 . 16 . 6	
12	Persian	6/6	3 . 18 . 0	
12	White Persian	6/6	3 . 12 . 0	
13	White Persian	6/6	1 . 11 . 6	
5	White Persian	5/6	1 . 2 . 6	
15	White	5/6	3 . 17 . 0	
14	White	5/6	2 . 6 . 0	
8	White	5/6	2 . 6 . 0	
4	White	5/6	1 . 2 . 0	
4½	White Persian	5/6	1 . 4 . 9	
	White Persian	5/6	4 . 5 . 6	
16	Black Persian	5/6	4 . 8 . 0	
16	Black Persian	5/6	4 . 8 . 0	
	Persian	5/6	4 . 16 . 0	

£ 91 . 16 . 0

Recd June 25 1791 on a Stamped Receipt

Wm King

PLATE 18

AN EXPRESSIONIST GOSPEL OF ST MATTHEW

1921, Germany

The German craftsman-scribe Rudolf Koch wrote astonishingly vigorous gothic hands but in an inimitable manner, and his work rarely looks anachronistic. The expressionist pen work is entirely in the spirit of post-World War I German art, yet the text is the Gospel of St Matthew.

Courtesy of the Klingspor Museum, Offenbach.

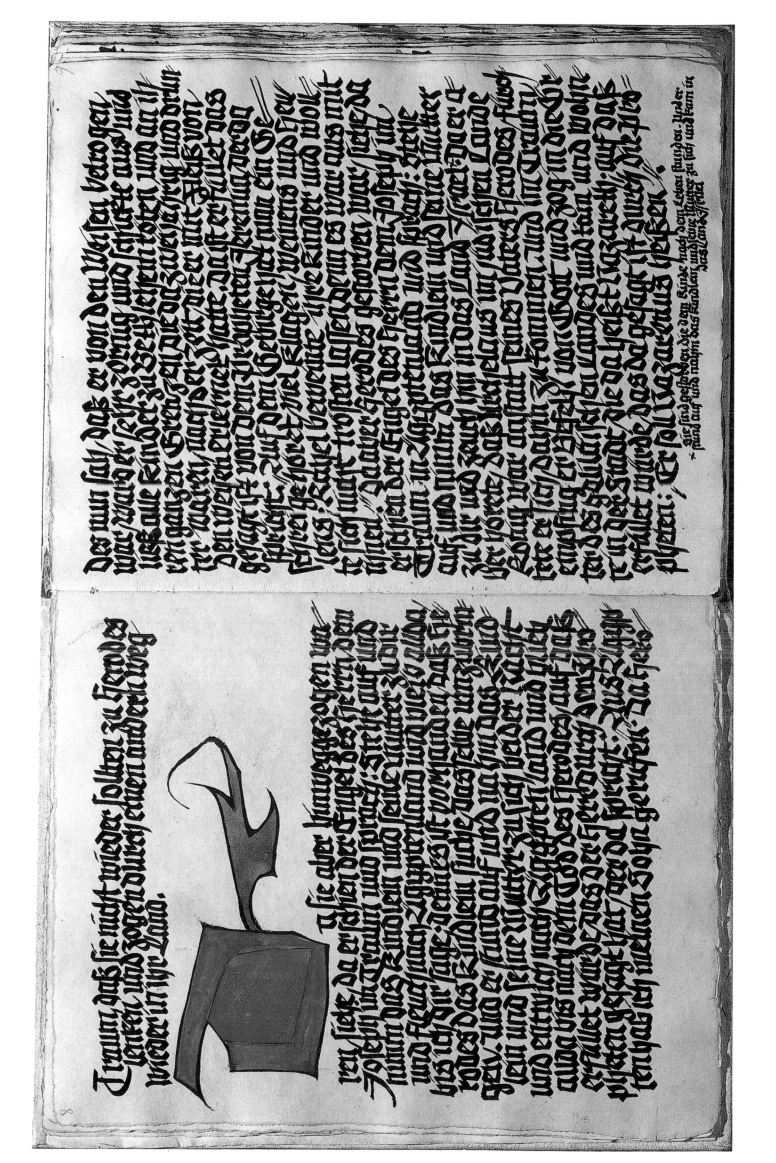

Da nun sah, daß er von den Weisen betrogen war, ward er sehr zornig und schickte aus und ließ alle Kinder zu Bethlehem töten und an ihren ganzen Grenzen, die da zweijährig und darunter waren, nach der Zeit, die er mit Fleiß von den Weisen erlernt hatte. Da ist erfüllet, das gesagt ist von dem Propheten Jeremia, der da spricht: Auf dem Gebirge hat man ein Geschrei gehört, viel Klagens, Weinens und Heulens; Rahel beweinte ihre Kinder und wollte sich nicht trösten lassen, denn es war aus mit ihnen. Da aber Herodes gestorben war, siehe, da erschien der Engel des Herrn dem Joseph im Traum in Ägyptenland und sprach: Stehe auf und nimm das Kindlein und seine Mutter zu dir und zieh hin in das Land Israel; *sie sind gestorben, die dem Kinde nach dem Leben standen. Und er stand auf und nahm das Kindlein und seine Mutter zu sich und kam in das Land Israel.

* Sie sind gestorben, die dem Kinde nach dem Leben standen. Hirtes nahm auf und nahm das Kindlein und seine Mutter zu sich und kam in das Land Israel.

Da er aber hörte, daß Archelaus im jüdischen Lande König war anstatt seines Vaters Herodes, fürchtete er sich, dahin zu kommen. Und im Traum empfing er Befehl von Gott und zog in die Örter des galiläischen Landes, und kam und wohnte in der Stadt, die da heißt Nazareth; auf daß erfüllet würde, das gesagt ist durch die Propheten: Er soll Nazarenus heißen.

Traum, daß sie nicht wieder sollten zu Herodes lenken, und sie zogen durch einen anderen Weg wieder in ihr Land.

PLATE 19

Einst dem Grau der Nacht enttaucht
AN ILLUSTRATED POEM BY PAUL KLEE

1918, Switzerland

The text of this watercolour is a mystical poem describing, with particular and general images, beginnings and growth (and perhaps endings too). Not always easy to read on the level of either comprehension or visual decipherment, Paul Klee's painting is verbally and visually dense. The monoline letters and the colour changes, and the underlying quasi-geometric structure delicately express feelings and moods grounded in the verbal imagery.

Courtesy of the Paul Klee Foundation, the Museum of Fine Arts, Berne.
©DACS, 1995

Einst dem Grau der Nacht enttaucht / Dann schwer und teuer / und stark vom Feuer /
Abends voll von Gott und gebeugt // Nun ätherlings vom Blau umschauert, / entschwebt
über Firnen / zu klugen Gestirnen.

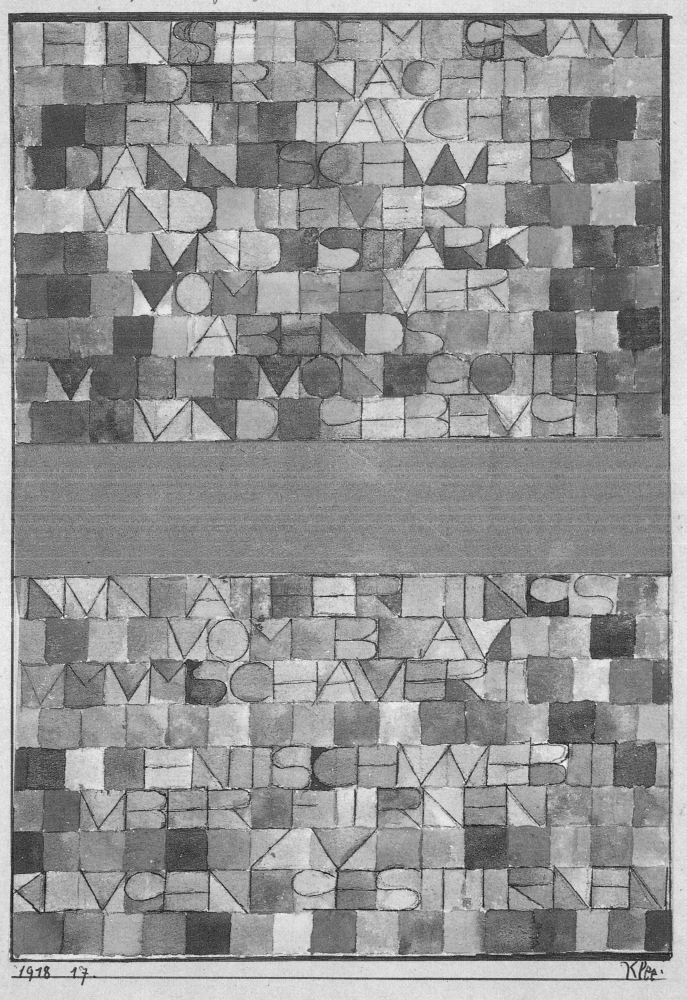

1918 17. Klee.

PLATE 20

Pwy Yw R Gwr
A LETTERED PAINTING BY DAVID JONES
1956, England

A design by David Jones for an inscription to be painted on a chapel wall, this is the largest of the artist's lettered paintings and the one he considered the most important. The upper passage, alternately Welsh and Latin, is an extract from a fourteenth-century poem by Welsh poet Gruffud Gryg and Latin translation. The lower passage is from the Latin Canon of the Mass with Welsh translation.

Courtesy of the National Library of Wales.

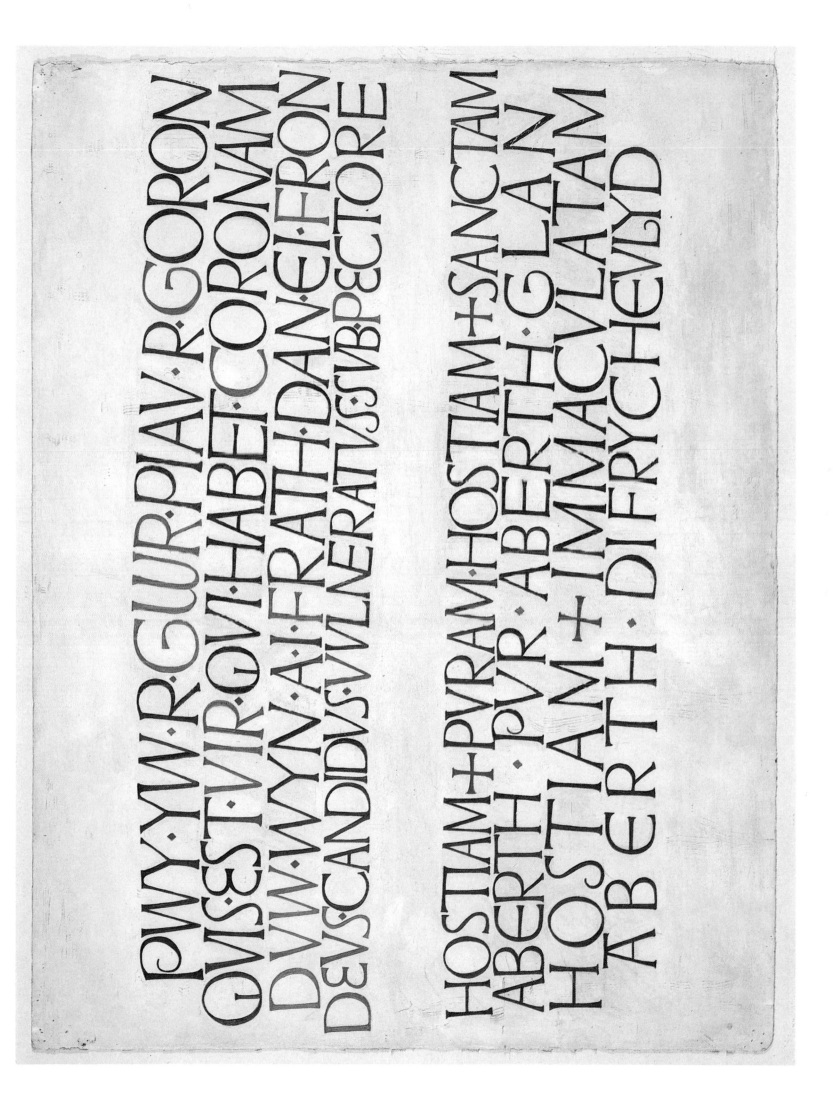

PLATE 21

Rose's Onion

PAINTINGS AND DRAWINGS BY ARNOLD BANK

1957, United States

The work of the American calligrapher-artist-teacher Arnold Bank has an enormous reputation although little of it has been published. Bank was fascinated by letters of all kinds and made many paintings and drawings of letters, usually alphabets or collections of letters rather than texts. His work was based upon a sound and wide knowledge of historical forms and at its best, as here, has a compelling poetry about it.

Private Collection.

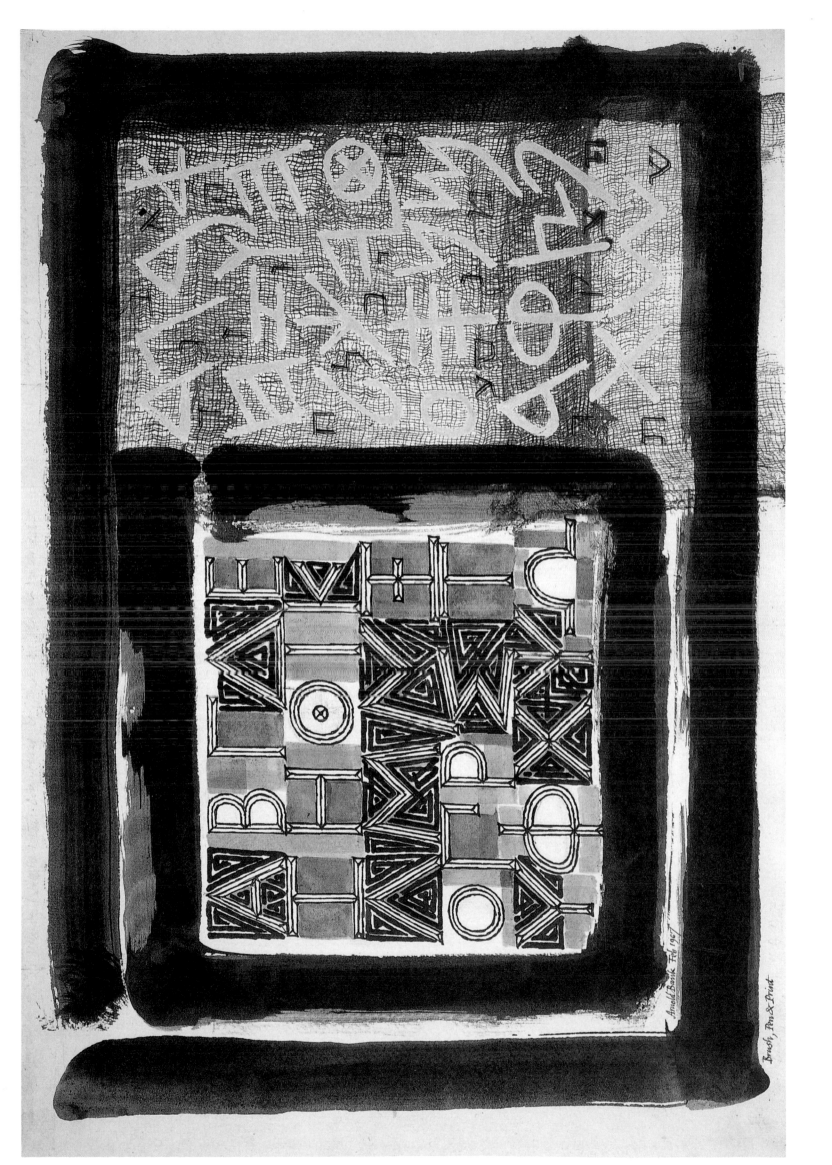

Arnold Bank Feb 1967

Brush, Pen & Print

PLATE 22

In the Beginning

A SCRIBE'S ARRANGEMENTS AND RELATIONSHIPS

1984, England

The theme of this piece by the English scribe Ann Hechle is the creation and redemption of humanity. It contains the opening of Genesis and St John's Gospel with a poem 'In the Beginning' by David Gascoyne, all artfully interwoven.

Private Collection.

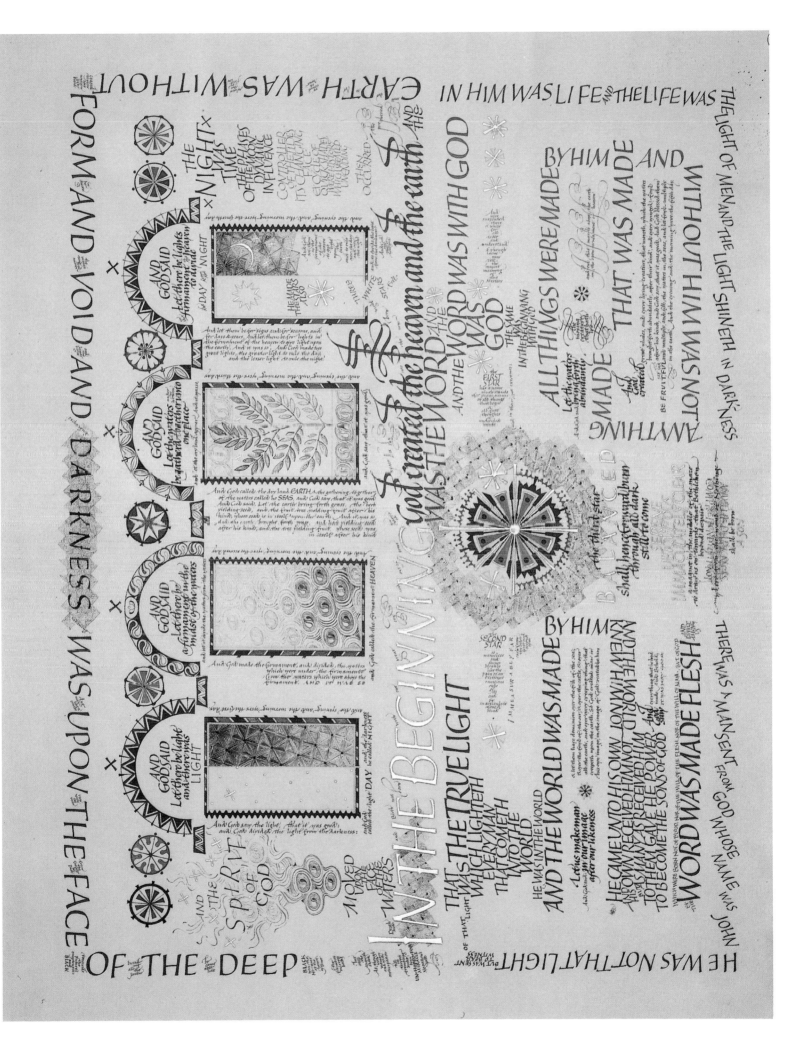

PLATE 23

Writing is the Optical Version of Speech
A POSTER ILLUSTRATES A TEXT

1988, United States

The piece was made as a poster for a lecture given by the designer and scribe Susan Skarsgard concerning her study experience with the Austrian calligrapher-teacher Friedrich Neugebauer. The text is from one of Neugebauer's books.

Private Collection.

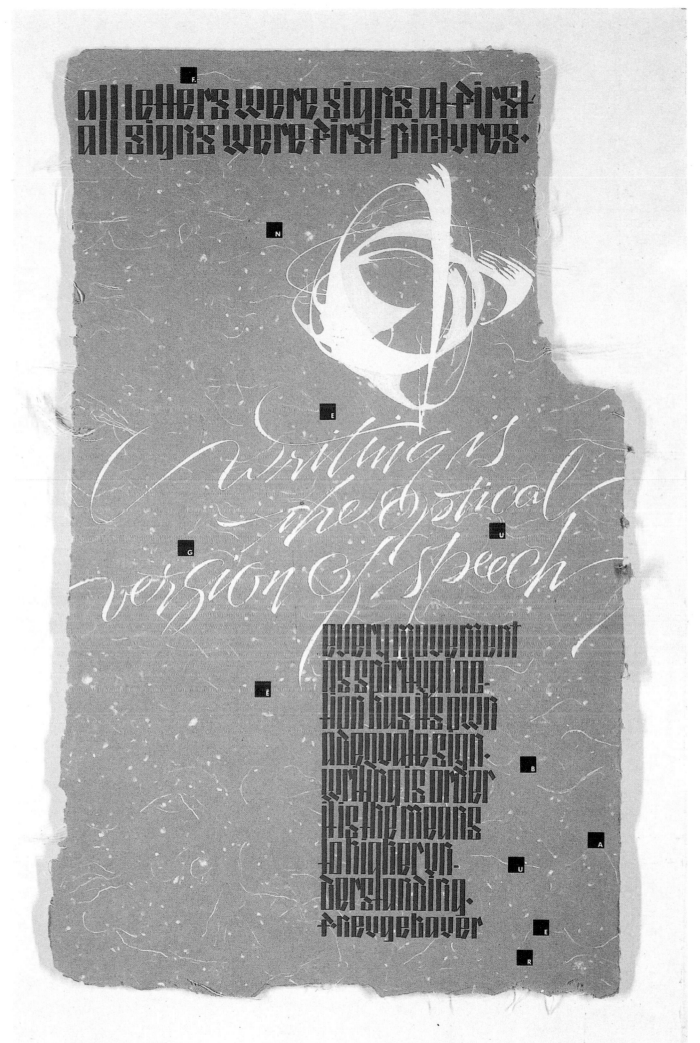

all letters were signs at first.
all signs were first pictures.

writing is
the optical
version of speech

every movement
as aspiration
tion has its own
adequate sign.
writing is order
His the means
to higher un-
derstanding.
-f.neugebauer

Friedrich Neugebauer is an internationally acclaimed calligrapher, graphic designer and teacher, as well as, author of The Mystic Art of the Written Forms -a beautifully written and illustrated handbook for lettering His career has spanned over 50 years, not only producing manuscript books and broadsides, but also designing books and book jackets, typefaces, urban signage syste s, advertising and corporate identity programs.

In May of last year, five calligraphers from the United States and Ireland were priviledged to study with Professor Neugebauer in an intensive seminar at his studio/home in Austria. Among those invited to this extraordinary experience was Ann Arbor calligrapher, Susan Skarsgard.

Susan is a lettering artist with Curley Campbel & Associates in Southfield and is editor/designer of Quill, the Journal of the Michigan Assoc. of Calligraphers. Her work has been published and exhibited widely including Print Regional Design Annual 1986-87, Scarab Club Advertising & Art Exhibition 1987, and Calligraphy Review 1988.

Detroit/AIGA will sponsor a slide/lecture on the Neugebauer experience by Susan Skarsgard on Wed., April 27th at 7pm at the Baldwin Library in downtown Birmingham, 300 W. Merrill, 647-1700. $3.00 donation for non-Detroit/AIGA members.

Design/Calligraphy: Susan Skarsgard Printing: The Hamblin Company Color Separation: SFC Graphic Arts Paper: Butler Paper Type & Production: Curley Campbell & Associates

PLATE 24

Romeo and Juliet

CALLIGRAPHIC PANEL FOR ROMEO AND JULIET

1989, United States

One of a series of panels, each devoted to a Shakespeare play, by the English-born scribe Charles Pearce who now lives in America. Pearce is one of the finest writers of modern times and his letters are based upon an intimate knowledge of historical forms freely interpreted and adapted for present needs.

Private Collection.

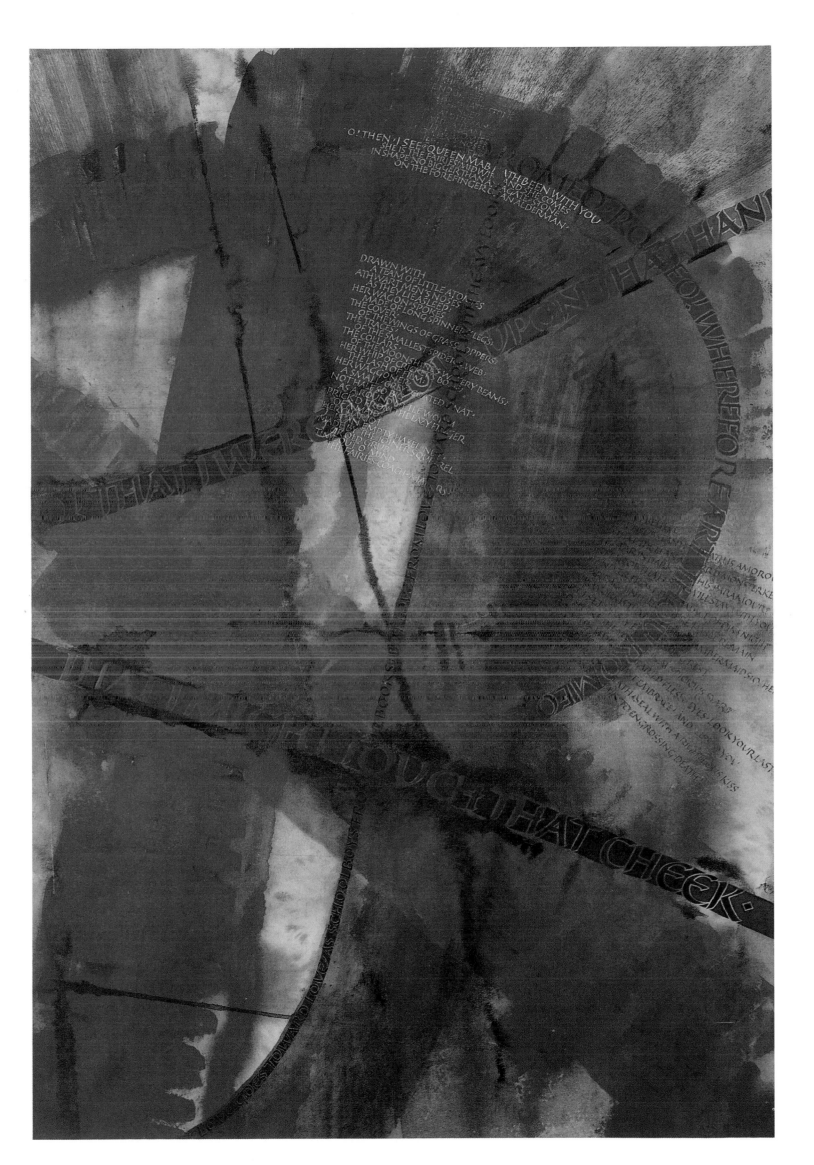

PLATE 25

Let Yourself Free, Number 2
THOMAS INGMIRE'S VISUAL AND VERBAL SKILL
1984, United States

The text comprises a number of extracts from the writings of the American artist Robert Henri, and makes pleas for self-development and the importance of the freedom of choice in art and life. The scribe-artist Thomas Ingmire responded to the text by using little abstract pictures of letters.

Private Collection.

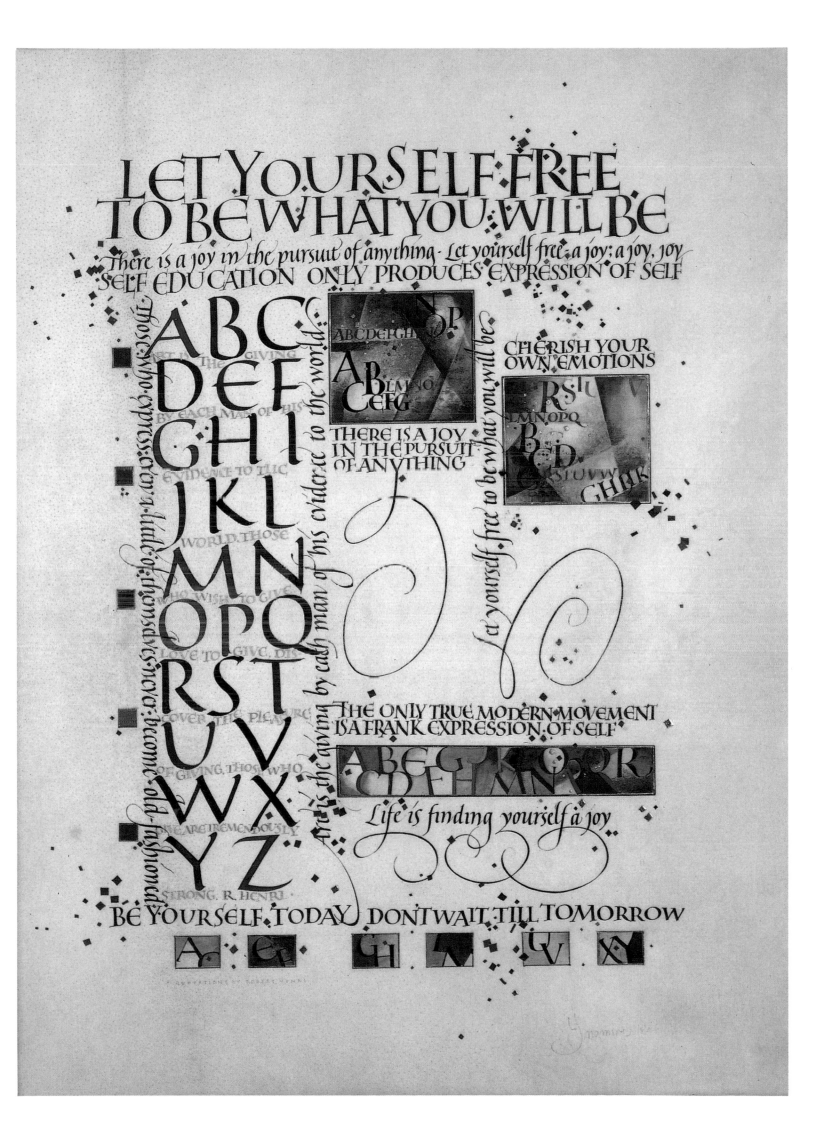

PLATE 26

The Drunken Boat

THOMAS INGMIRE'S RESPONSE TO A POEM BY RIMBAUD

1988, United States

The artist Thomas Ingmire used words and phrases from a translation of a Rimbaud poem in this piece. The highly charged painted surface and the blurring of verbal and visual elements are to present a purely visual experience of line, movement and colour, to generate and convey emotions. It is a highly sophisticated work and few other living artists have so convincingly used texts to make statements about feelings.

Private Collection.

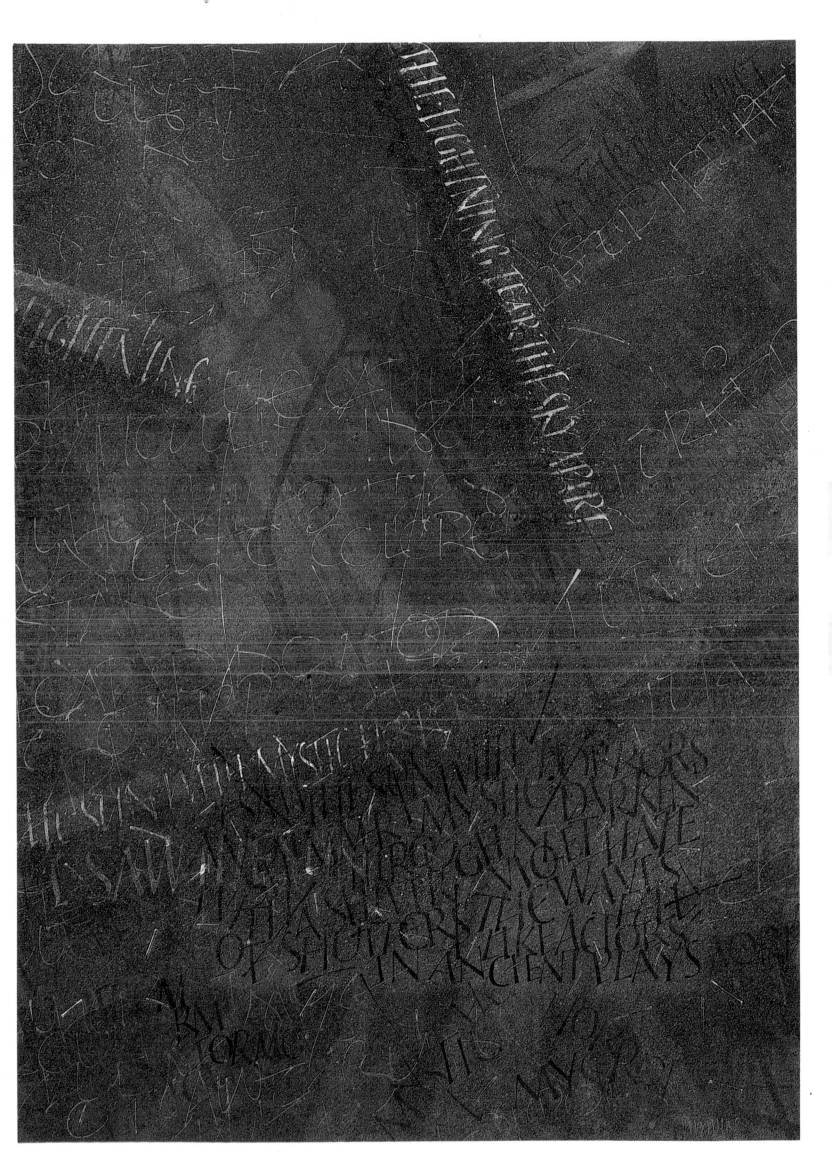